Rays of Hope
Photo Inspirations

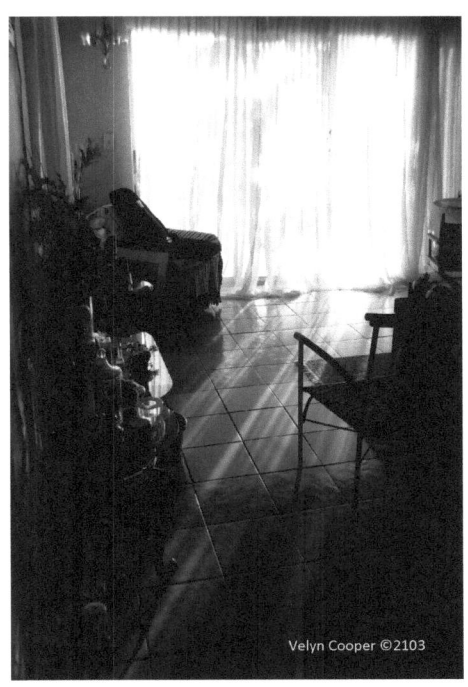

Velyn Cooper

Copyright 2013 Velyn Cooper

All rights reserved. No part of this publication may be reproduced, stored in a retrieval system, transmitted, in any form or by any means, electronic, mechanical, photocopying, recording, or otherwise, without prior permission of the author.

ISBN-10: **1484829611**

ISBN-13: **978-1484829615**

VC Productions

vcproductions1@gmail.com

The Empty Chair

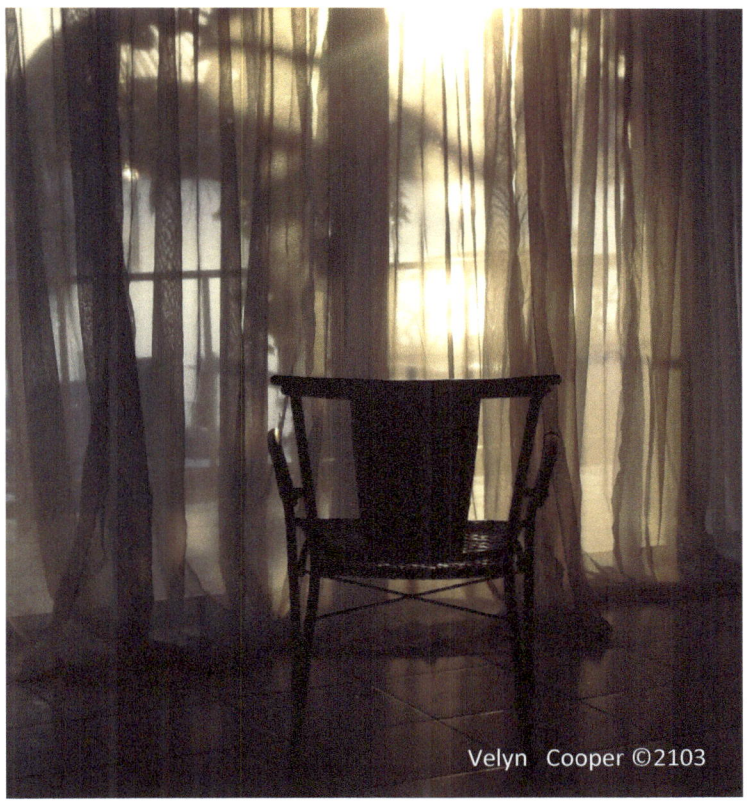

I awoke, expecting to see him sitting in his favorite chair entranced by the beauty of the sunrise, as the rays of light broke through the darkness, giving birth to a new day. As soon as I entered the room I saw it and remembered ... He's gone and my mornings will now begin with the empty chair.

Your Influence

Velyn Cooper ©2103

Whatever you do
Always remember that it affects many other people –
sometimes even those you may not know.

Clear View

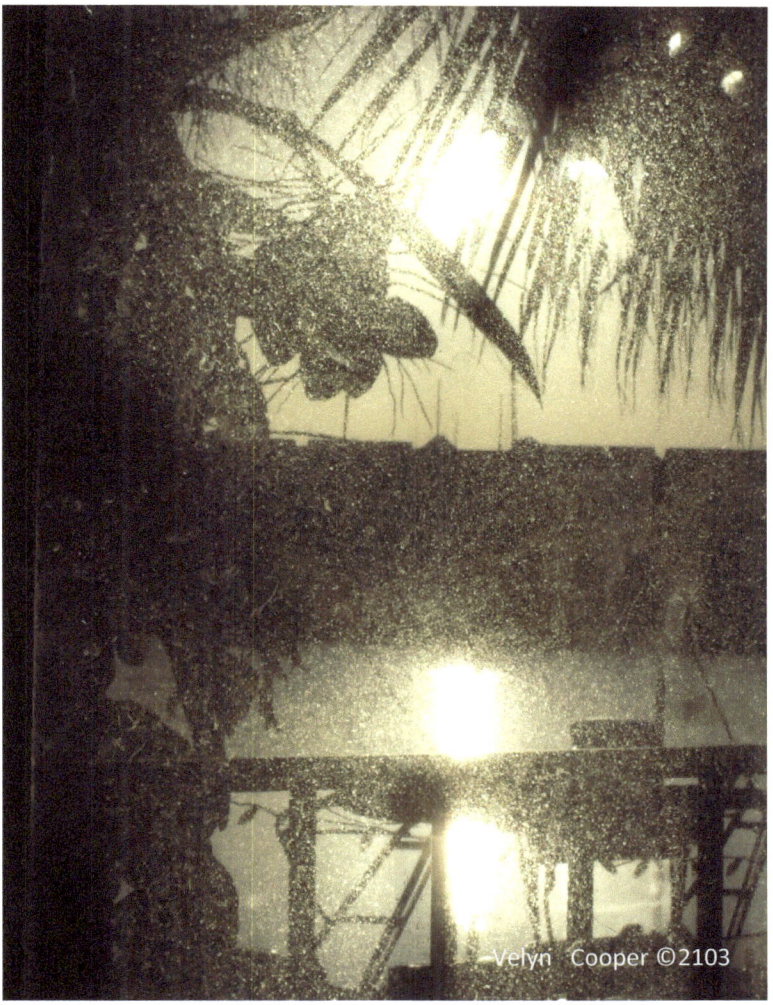

—Velyn Cooper ©2103

To get a clear view of where you are going, you need to step out of your comfort zone.

Rays of Hope

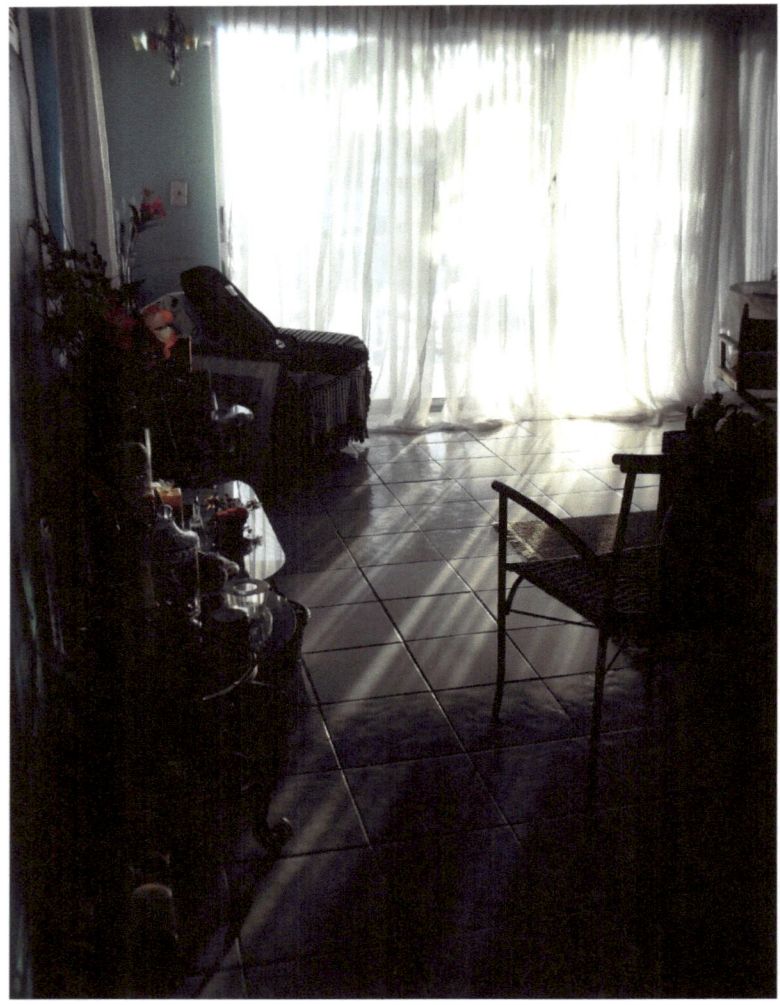

The rays of hope are but a glimpse of the fullness of the blessings God has in store for those who love Him and live for Him, according to the teachings He has outlined in His word.

Glory of God

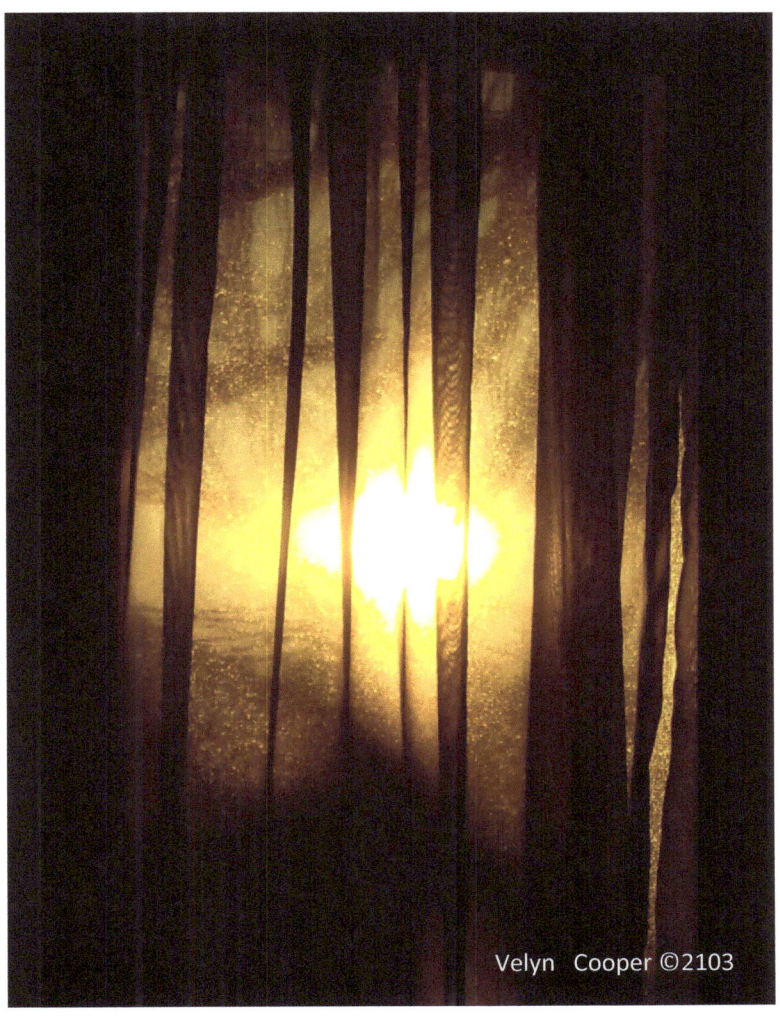

The glory of God is visible to all –
some just refuse to acknowledge it.

Reflection

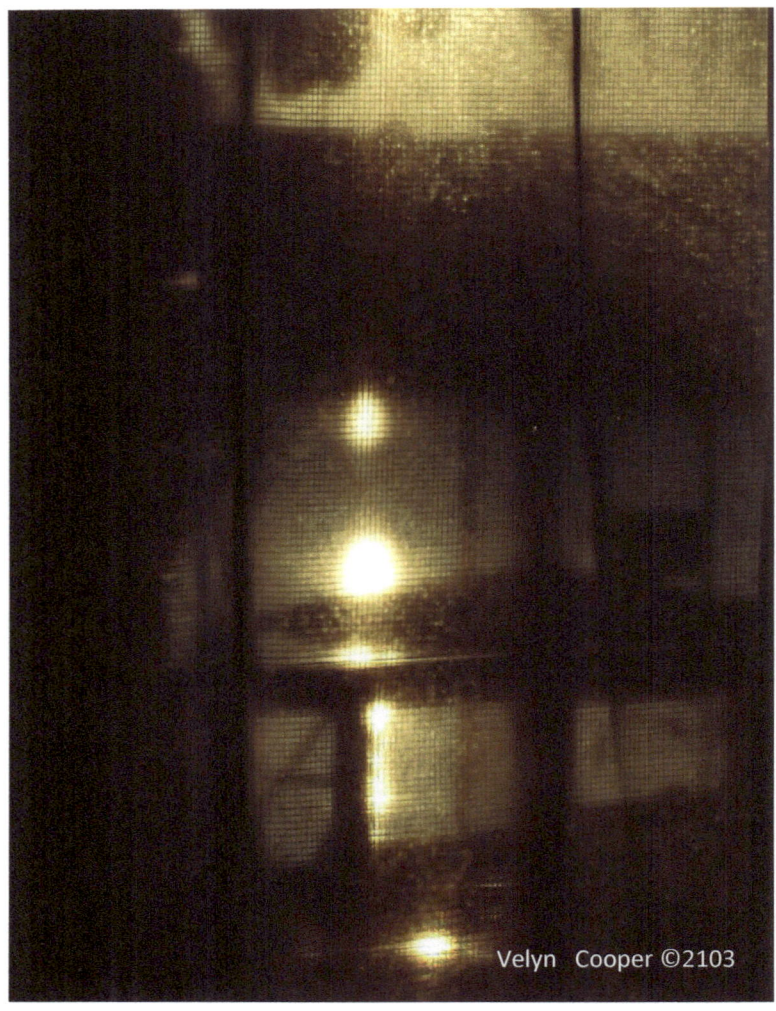

Let the reflection of Christ in your life
be an example for others to follow.

Door to Success

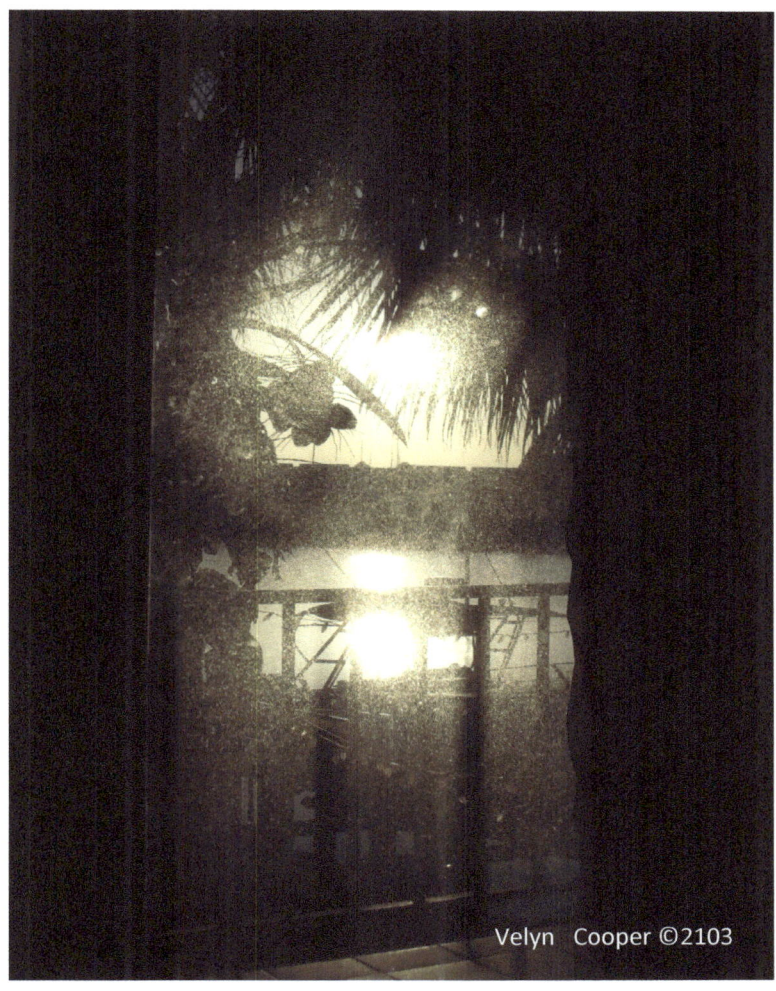

The door to your success is wide open; it may be surrounded with discouragement –DO NOT LOSE YOUR FOCUS!

Blessings of God

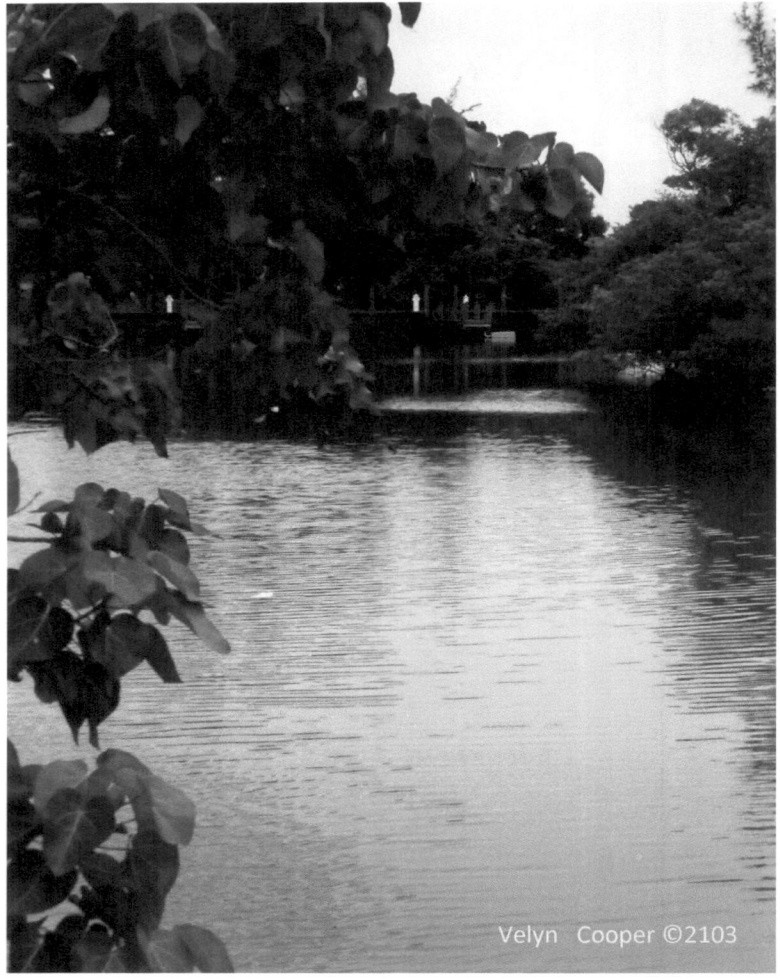

The blessings of God are never ending – we just need to operate in His will in order for them to be sustained in our lives.

Light of God

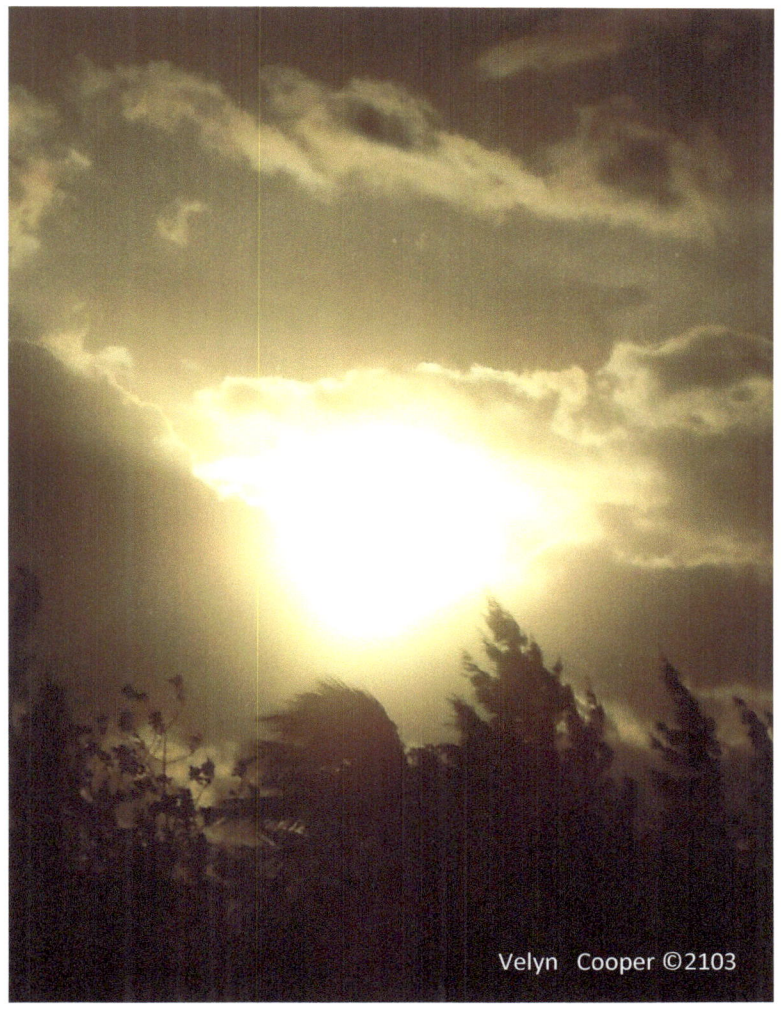

Velyn Cooper ©2103

Look toward the light of God in His word and you will never lose your sense of direction.

The Path of God

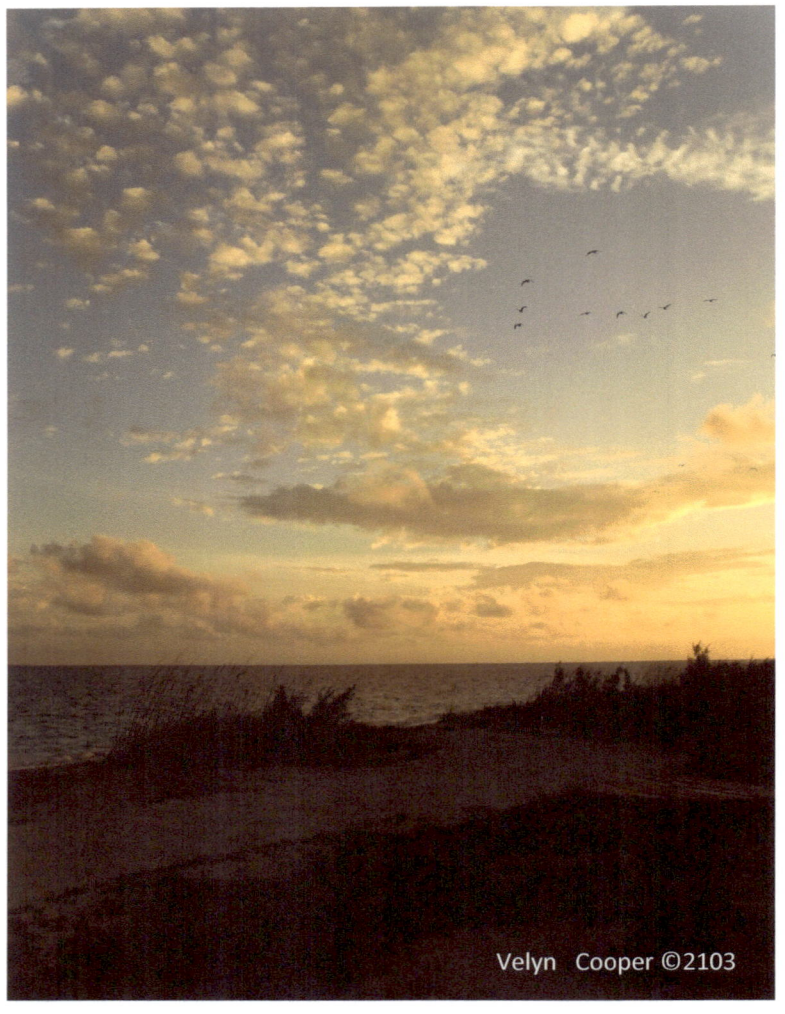

Follow the path of God as outlined in His word and you will walk in the fullness of His blessings.

Reach Out to God

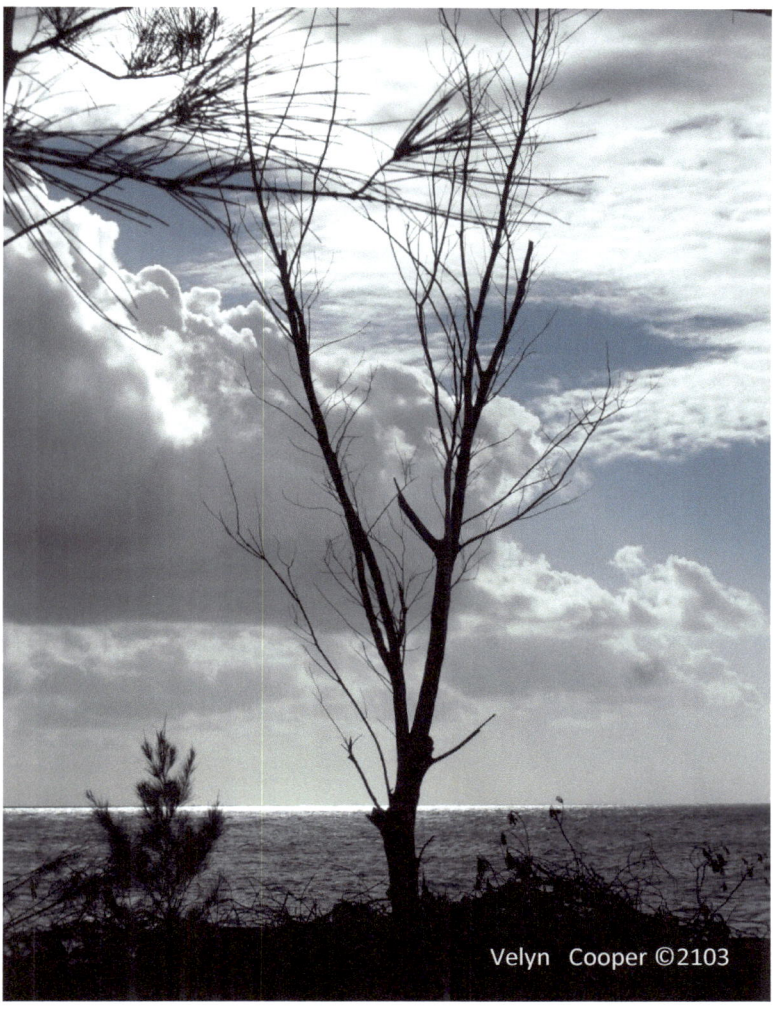

Reach out to God as He reaches out to you.

Beauty of God

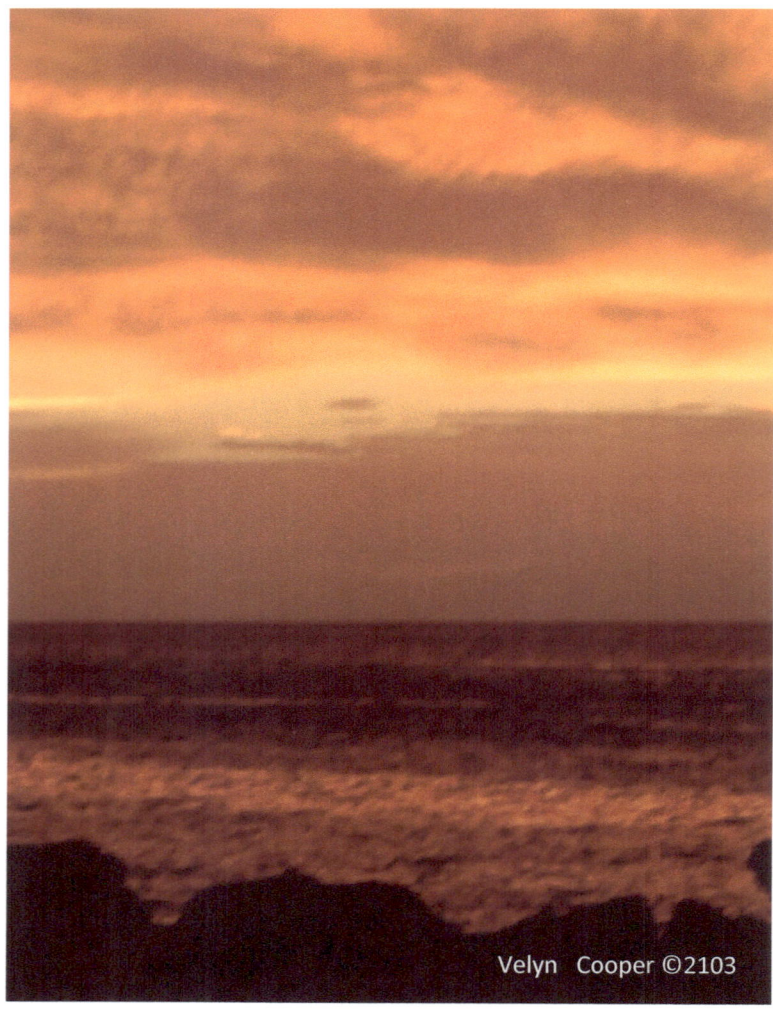

Velyn Cooper ©2103

The beauty of God is expressed in many shade and colors.

The Love of God

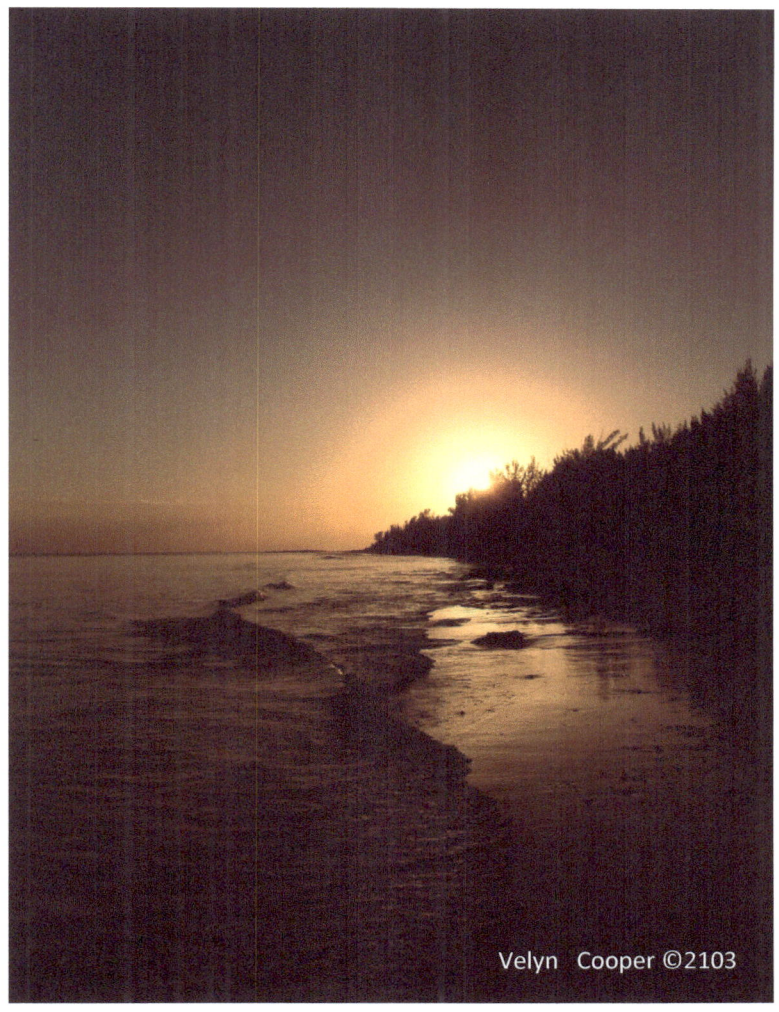

Let the love of God in your heart affect everyone in your path.

Maximizing Your Potential

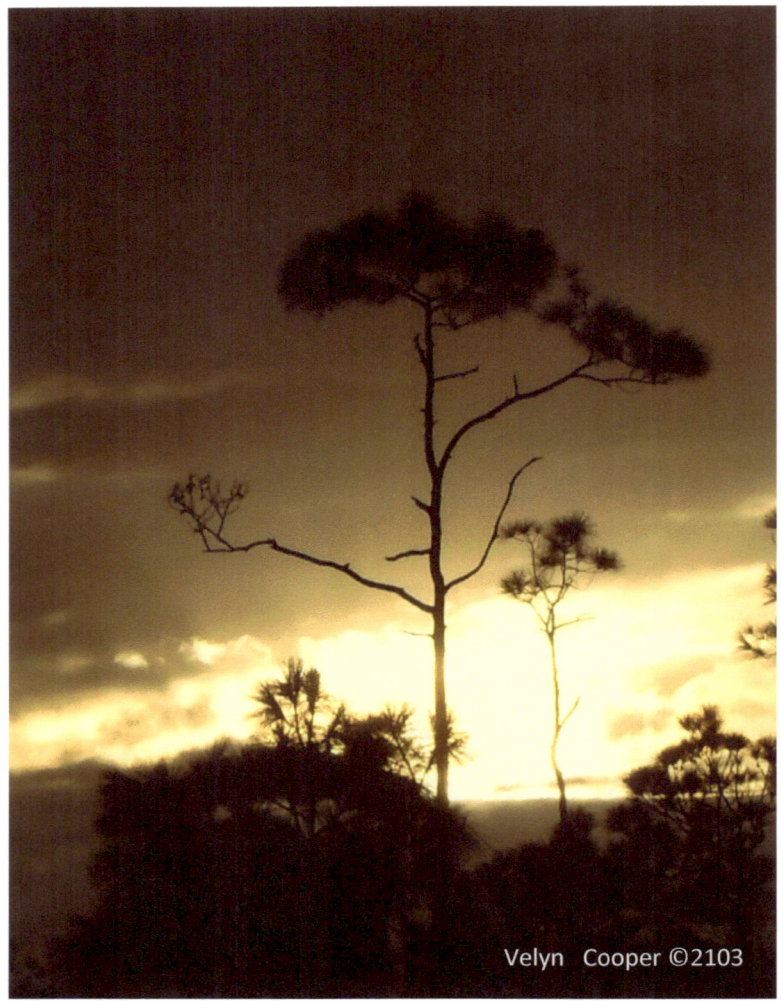

Velyn Cooper ©2103

Rise above the crowd and maximize your potential in God.

The Strength of God

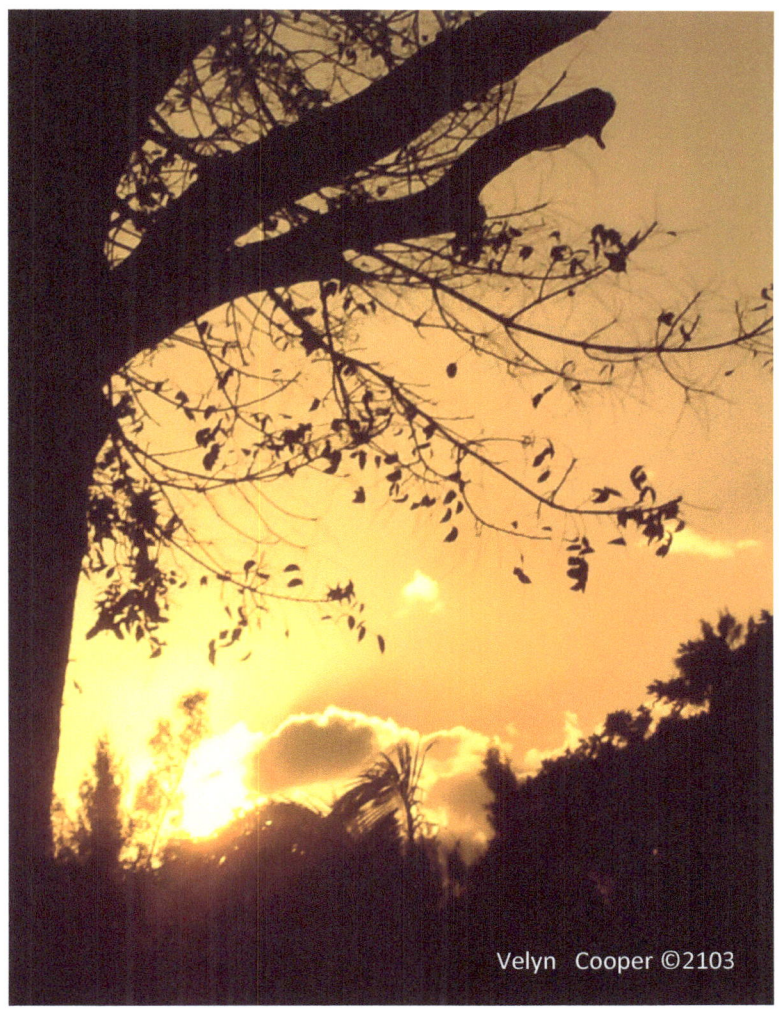

Velyn Cooper ©2103

The strength of God will always support you and His light will always guide you.

Distraction Vs Focus

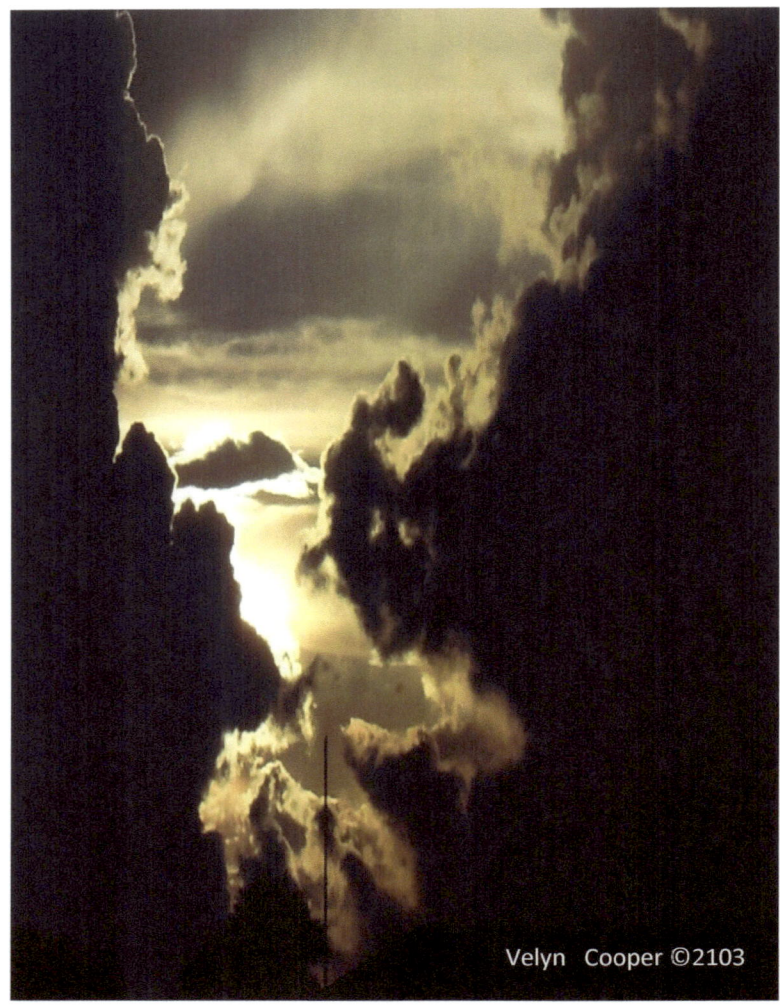

Don't let the distraction become your focus.

The Light of God

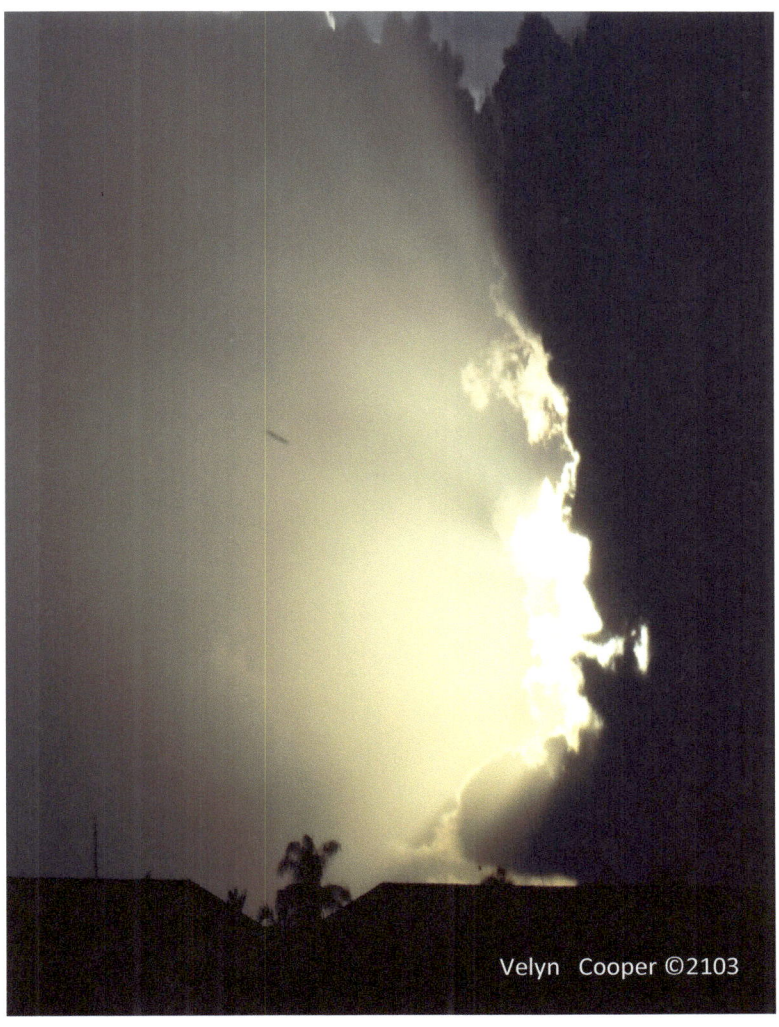

Let the light of God within you burst forth and impact the world.

Guide

Velyn Cooper ©2103

Sometimes the only guide a person has is you - make sure you are walking in truth.

God's Gateway

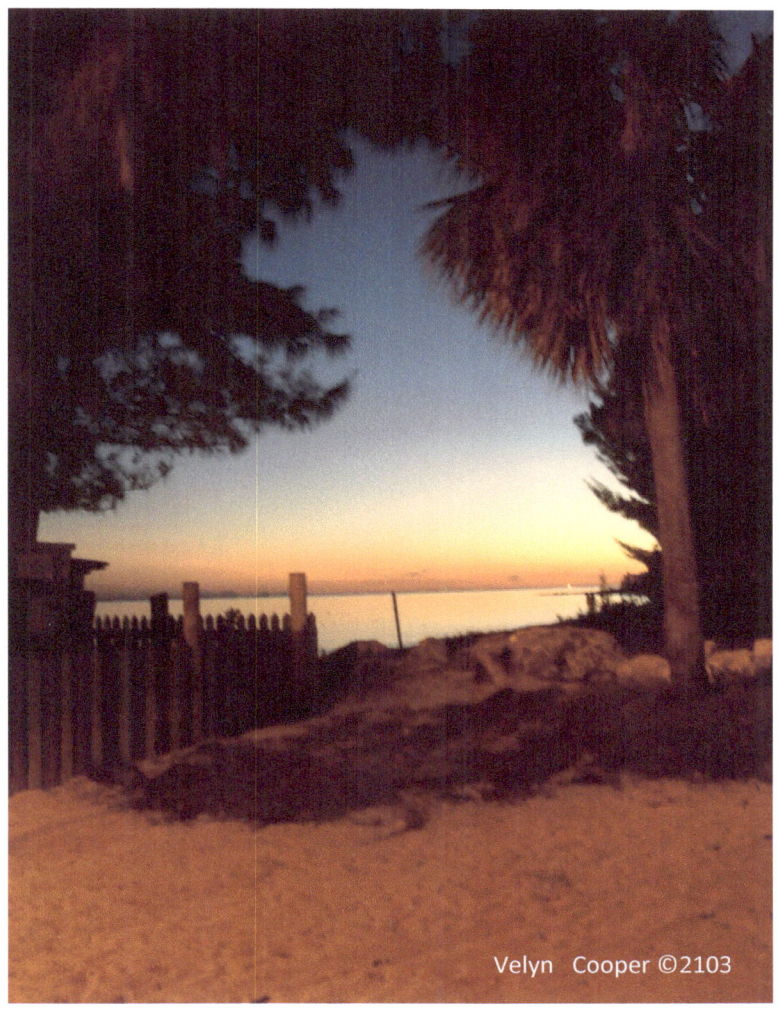

God has given us a gateway to Him – His Son, Jesus Christ.

Our God is Awesome

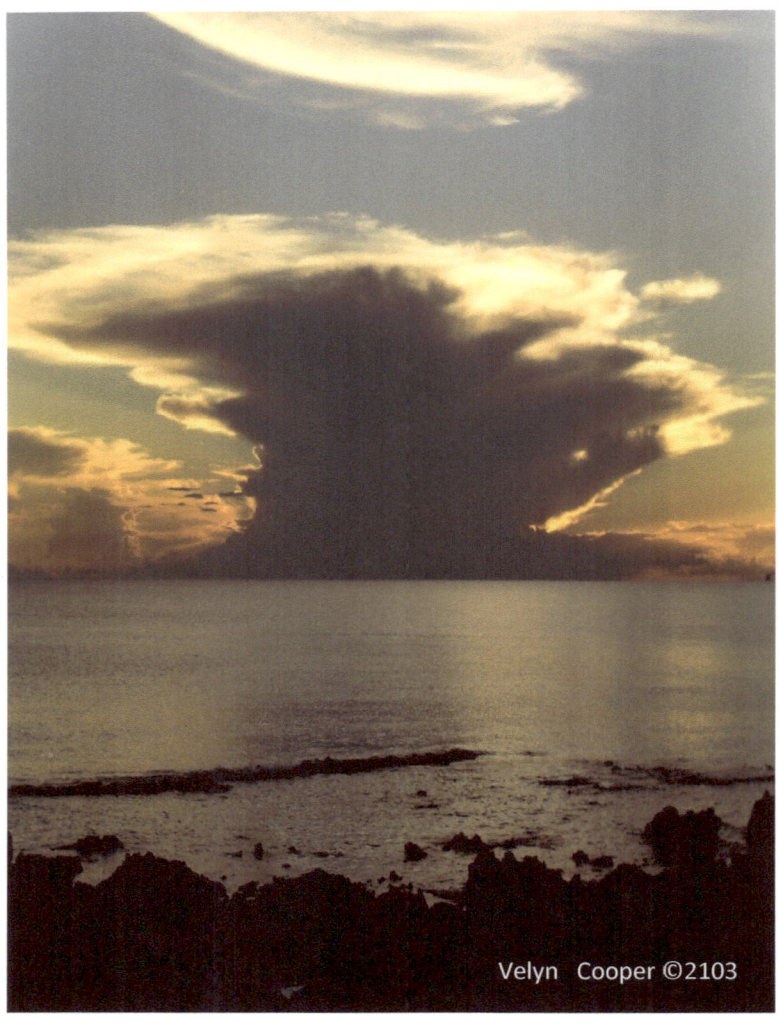

How great and awesome is our God.

Publications by Velyn Cooper

Biblical Journeys: Passages Through Time and Into Eternity
Expressions of Love
Happy Mother's Day
High School Girls- Build A Strong Foundation & Face Your Future Prepared & Courageous
High School Girls- Build A Strong Foundation & Face Your Future Prepared & Courageous
Look to God in Faith
My Redeemer Lives – Photo Essay
Natural Arrangements – Unity in the Midst of Diversity
Poetry From the Heart
Reflections: A 90-Day Devotional
Renewing Your Mind — Transformation is a Lifelong Process
Rusty The Rat (Children's Book)
Shades of Pink – in Memory of Hartlyn Cooper Martin
The Beauty of Freeport, Grand Bahama, Bahamas
The Journey to Becoming a True Woman of Virtue
Thoughts: A Book of Quotes
Transitioning High School and Beyond —The Journey Begins
Understanding God Through Repentance, Confession and Baptism, Salvation
What Does The Bible Say About…?

If you would like to contact the author, please send your questions or comments to:

Velyn Cooper

P. O. Box F42524

Freeport, Grand Bahama

Bahamas

Email: biblicaljourneys@gmail.com

Website: biblicaljourneys.net

www.ingramcontent.com/pod-product-compliance
Lightning Source LLC
Chambersburg PA
CBHW041622180526
45159CB00002BC/973